ST ALBANS
HISTORY TOUR

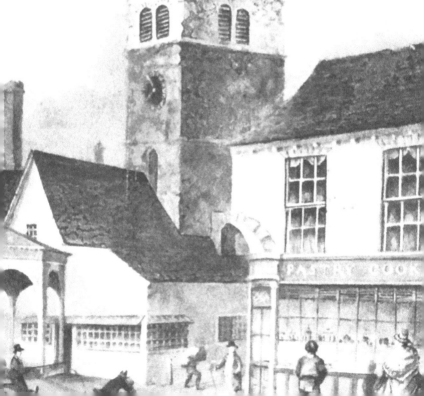

PASTRY COOK

First published 2016

Amberley Publishing
The Hill, Stroud,
Gloucestershire, GL5 4EP
www.amberley-books.com

Copyright © Robert Bard, 2016

The right of Robert Bard to be
identified as the Author of this work
has been asserted in accordance with
the Copyrights, Designs and Patents
Act 1988.
Map contains Ordnance Survey data
© Crown Copyright and database right
[2016].

ISBN 978 1 4456 5761 5 (print)
ISBN 978 1 4456 5762 2 (ebook)

British Library Cataloguing in
Publication Data.
A catalogue record for this book is
available from the British Library.

Typesetting by Amberley Publishing.
Printed in Great Britain.

INTRODUCTION

St Albans is a city which has developed rapidly since the arrival of the railway in the mid-nineteenth century, but has managed, unlike many modern cities, to retain much of its historic character. The ancient Roman ruins were very much recycled to build later structures, including parts of the Abbey and the gatehouse. The small red bricks are easily spotted. The massive Beech Bottom Dyke, probably constructed between AD 5 and 40 by the Catuvellauni, was used in 1461 as a defence by the Earl of Warwick (Warwick the Kingmaker) at the Second Battle of St Albans.

A number of ancient writers left accounts of events in St Albans so that comparing the landmarks of the past with the modern is reasonably straightforward. The names of the primary streets and districts have largely retained their names for several hundred years. The Abbey and Cathedral dominate the town and are visible for many miles around. The Abbey Gateway was built around 1360. During the Middle Ages, the Abbey and the townsfolk were constantly in conflict. The Gateway was besieged in 1381 during the Peasants' Revolt, one of the leaders of which, the radical priest John Ball, came from St Albans.

Nearly a century later, on 22 May 1455, St Albans hosted the opening conflict of the Wars of the Roses. This was at Key Field, now the site of a car park. It is interesting when walking along Market Place and St Peter's Street to think that Henry VI raised the Royal Standard, a declaration of war, in the vicinity of what is now the Boots store in St Peter's Street. It was also here that he was injured in the neck by an arrow. Four of the King's bodyguards were killed and the Royal Standard was abandoned.

The Abbot, John of Whethamstede, observed and recorded the vicious fighting which took place a few hundred metres away around the Clock Tower and Market Place from a window of the Gateway: 'Here you saw one fall with his brains dashed out, there another with a broken arm, a third with a cut throat, and a fourth with a pierced chest, and the whole street was full of dead corpses.'

It was where the estate agent Connells is situated that, in the same conflict, the Duke of Somerset was killed. A contemporary source describes his demise: 'York's men at once began to fight Somerset and his men, who were within the house and defended themselves valiantly. In the end, after the doors were broken down, Somerset saw he had no option but to come out with his men, as a result of which they were all surrounded by the Duke of York's men. After some were stricken down and the Duke of Somerset had killed four men by his own hand, so it is said, he was felled to the ground with an axe, and at once wounded in so many places that he died.'

By the nineteenth century the Abbey, notable for its magnificent architecture as well as thirteenth- and fourteenth-century wall paintings, was on the verge of ruin and collapse, but was 'saved' by a local beneficiary. As well as the Market Place and Abbey, another favourite of mine for comparing past and present is Holywell Hill, where, until 1827, once stood Holywell House at the bottom on the east side. It was formerly the home of Sarah, Duchess of Marlborough. She and the Duke of Marlborough occasionally resided here. Echoes of the house in the form of Holywell Lodge remain. As a major coaching route on Watling Street, as well as being a place of pilgrimage, the city was, and still is, blessed with numerous inns. At the top of Holywell Hill is the fifteenth-century White Hart. In 1792 a traveller commented that it was 'perhaps the best here', but the inn was 'unequalled in filth, inattention and charge'. It is supposedly haunted by the decapitated passenger on a coach who failed to duck when the coach passed under the arch when it entered the yard!

ACKNOWLEDGEMENTS

I would like to thank the members of the St Albans and Hertfordshire Architectural and Archaeological Society (SAHAAS), particularly Donald Munro, President, and Gill Harvey for assisting me. David Thorold, Keeper of Archaeology, at the Verulamium Museum provided me with a number of the older images. I would also like to thank Tom Entwistle, a descendent of Sir Bertine, for providing me with the appropriate illustration (Entwistle was a knight who fought at St Albans during the Wars of the Roses and is buried in the nave of St Peter's Church) and Peter Burley of the Battlefield Trust for walking me around the Wars of the Roses sites in St Albans.

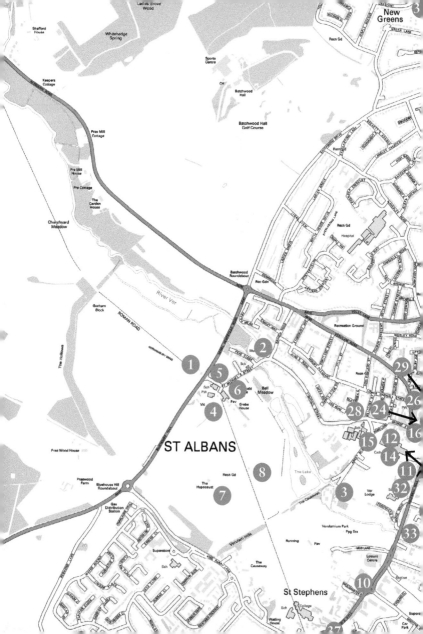

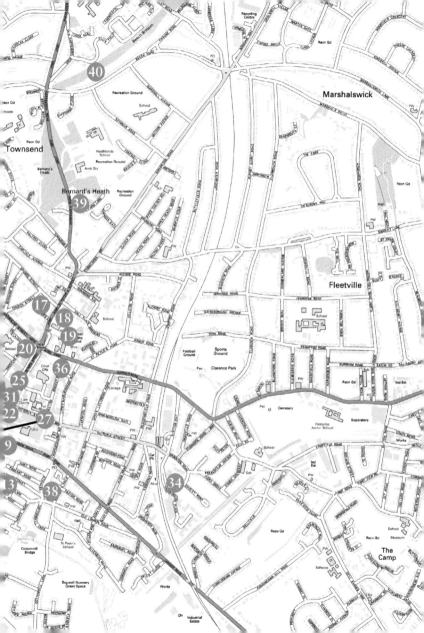

1. ROMAN THEATRE OF VERULAMIUM

The Roman Theatre of Verulamium was built in around AD 140 and was a theatre rather than an amphitheatre. It was extended in around AD 180, and again in c. AD 300. The theatre could seat 2,000 spectators. The ruins in the picture were unearthed in 1865 and excavated in 1935. The remains are located near St Michael's Village and the Verulamium Museum along the original Watling Street.

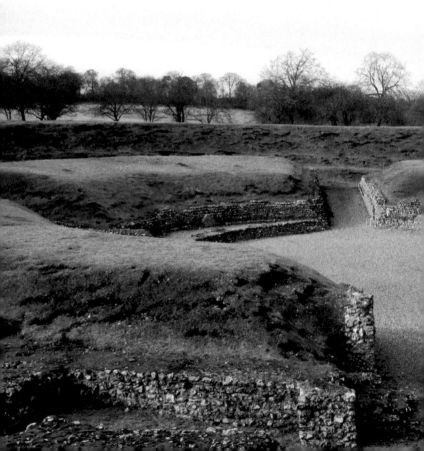

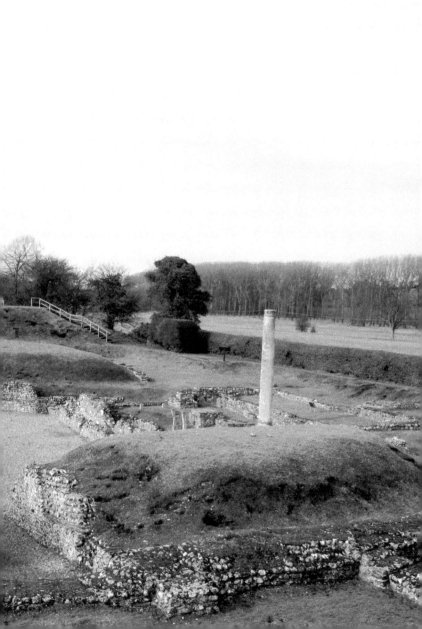

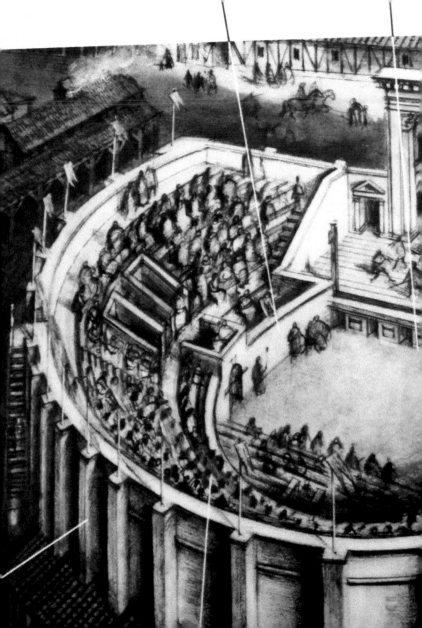

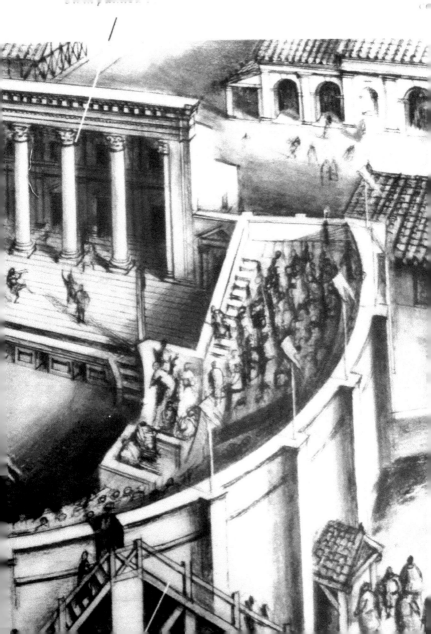

2. ST MICHAEL'S BRIDGE

Here is a picture of St Michael's Bridge and Kingsbury Mill. The bridge was built in 1765 at a cost of £280. There was an earlier bridge or bridges as they were mentioned in relation to the Second Battle of St Albans in 1461: 'Pons de la Maltemyll'. The Mill is now a restaurant and museum. It was mentioned by inference in the Domesday Book of 1086. The photograph dates from *c.* 1905.

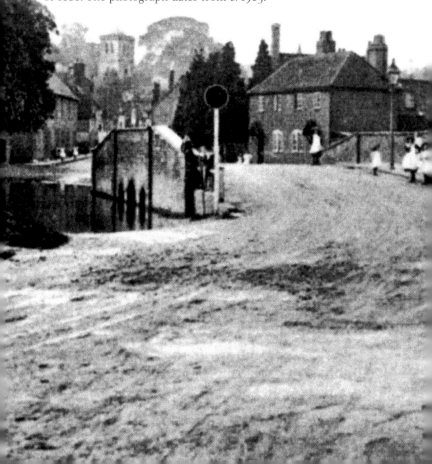

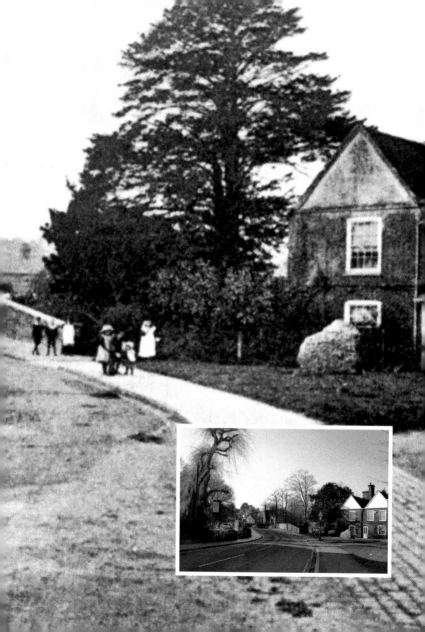

3. THE SILK MILLS

Now replaced by modern dwellings opposite the Ye Olde Fighting Cocks Inn, Verulam Park, were the Abbey Mills. The mills were converted to make silk in 1804, before which they ground corn. The old illustration dates from *c.* 1910. In the 1880s, the mill employed 'over 300 hands. The silk mills were closed in the 1930s and were demolished in the 1950s.

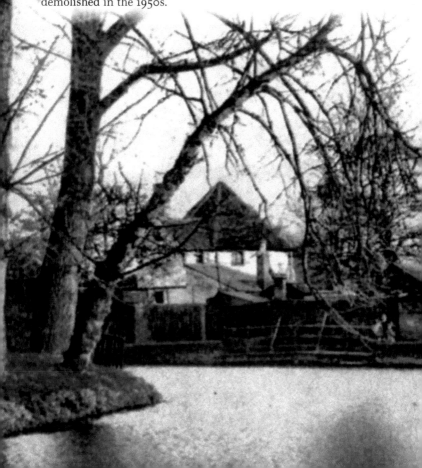

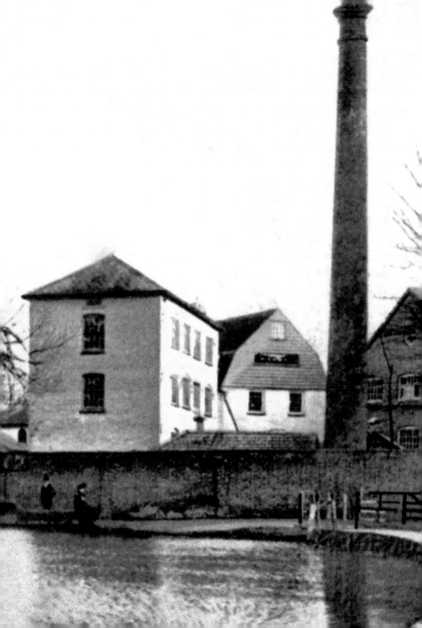

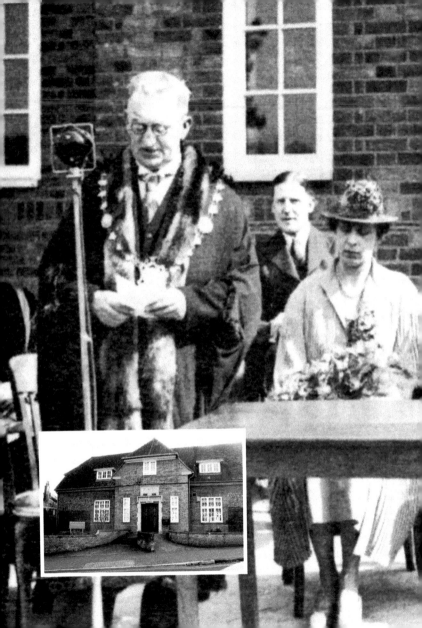

4. VERULAMIUM MUSEUM I

The museum opened on 8 May 1939. In the photograph are the mayor, welcoming the Earl of Harewood and the official party who are from left, the town clerk, Princess Mary, the Earl of Harewood and the mayoress.

The Verulamium Museum has been completely modernised and houses the original Wheeler finds from the 1930s excavations as well as a major collection of Roman artefacts including some of the finest mosaics in the country. Included in the displays are the remains of a burial of a local king unearthed in Folly Lane in 1992 which included the remains of enamelled horse equipment, a chariot and iron mail armour. Also on display are several iron plates from a legionary's body armour which were found in a pit outside the town. The museum stands in the middle of the site of the Roman city of Verulamium.

5. ST MICHAEL'S

The 1916 class of children at St Michael's (inset), a Church of England voluntary aided primary school, founded in 1811 by the 2nd Earl of Verulam to provide an education for the local poor children. It became a church school in 1876. The school is situated next to the church opposite the Verulamium Museum.

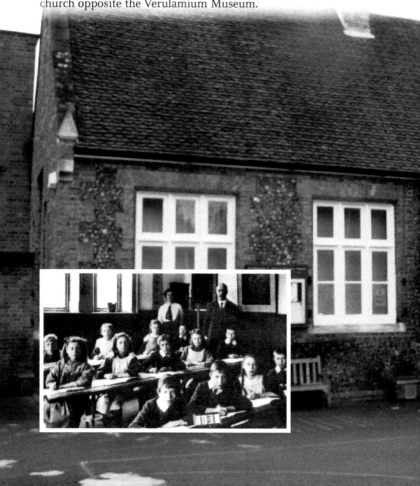

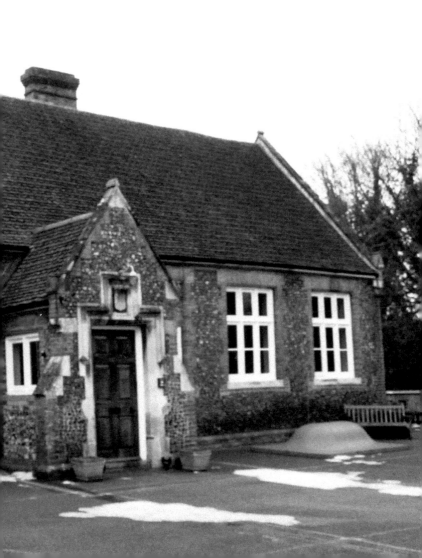

6. ST MICHAEL'S CHURCH

The old photograph depicts St Michael's church before restoration. A gardener can be seen tending the graveyard in this image dating from *c.* 1880.

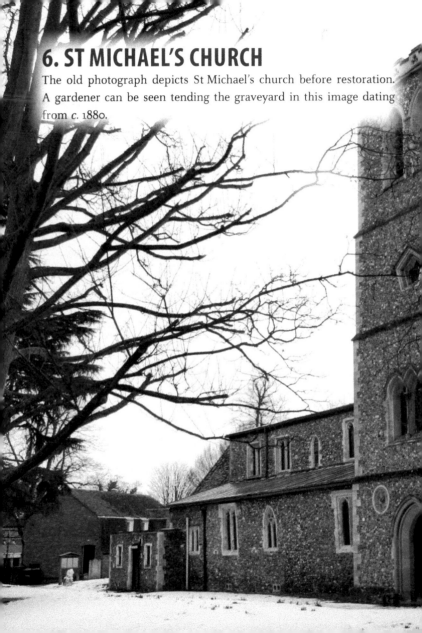

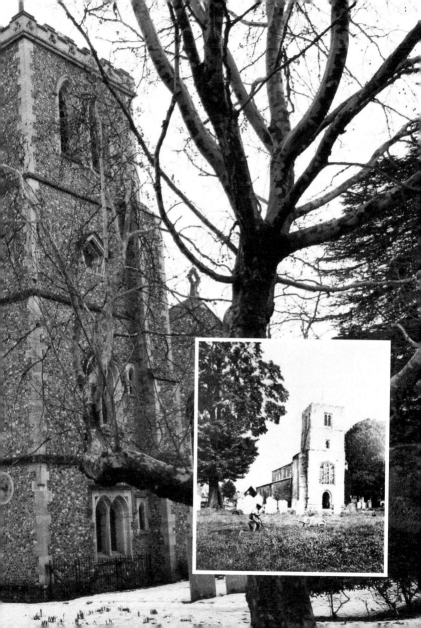

7. HYPOCAUST MOSAIC

Tessa Wheeler, wife of Mortimer Wheeler, is sweeping the hypocaust mosaic during excavation in 1932. Below is the mosaic floor which contains around 220,000 tesserae. It is likely that this was the home of an official or aristocrat. It has been suggested that the mosaic took two seasons to lay, as indicated by a change in tesserae colour and some laying 'mistakes'.

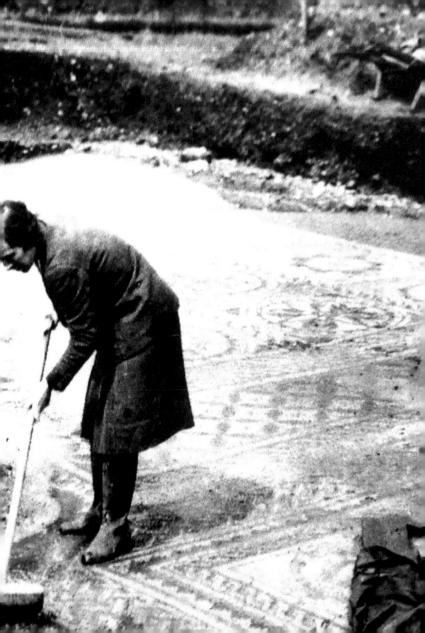

8. THE ROMAN WALL

The Roman wall is situated in what is now Verulamium Park, and from here there is a spectacular view of the Abbey. Built AD 256–70, it was 5 metres high, with a parapet and walkway on top, and it extended for 2 miles. Other sections still survive. Situated in the immediate vicinity are the remains of a major 1,800-year-old town house hypocaust with a mosaic.

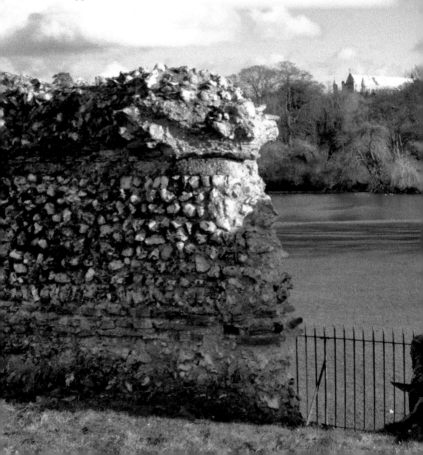

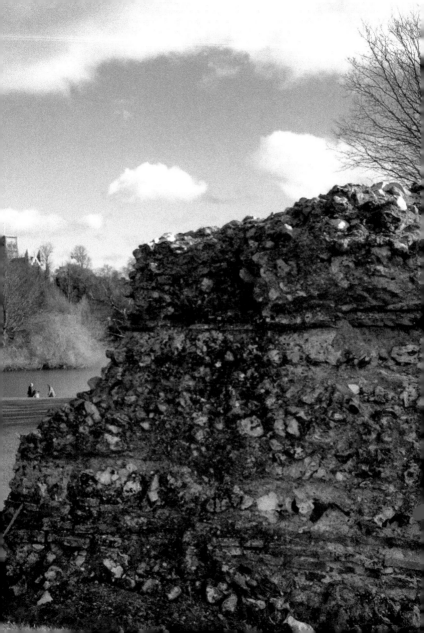

9. PEAHEN

The *Victoria County History of 1908* tells us, 'Before the present London Road was made in 1794 there was no road eastward from St Peter's Street and Holywell Hill (formerly Holywell Street) between Victoria Street and Sopwell Lane, then the London Road. Between these points on the steep hill into the town were the principal inns. Of those that now remain the Peahen, which stands at the south corner of the London Road, is, perhaps, the most important. This dates back to the fifteenth century, but the house has recently been entirely rebuilt in a style which cannot be said to harmonise with its surroundings; the only relic of the old inn is some sixteenth-century woodwork in the coffee room.'

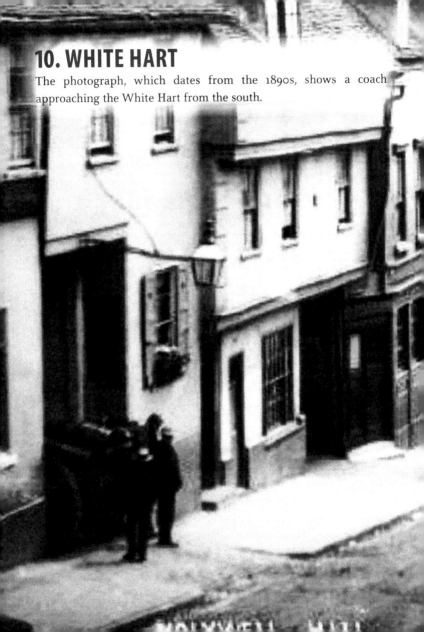

10. WHITE HART

The photograph, which dates from the 1890s, shows a coach approaching the White Hart from the south.

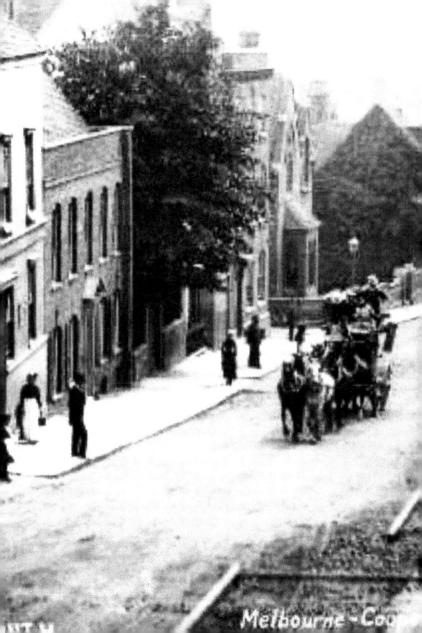

Melbourne - Coop

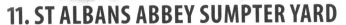

11. ST ALBANS ABBEY SUMPTER YARD

Access to the Sumpter Yard is via Holywell Hill opposite the White Hart, as it has been for many centuries. The cedar tree shown was planted by the Dowager Lady Spencer on 25 March 1803.

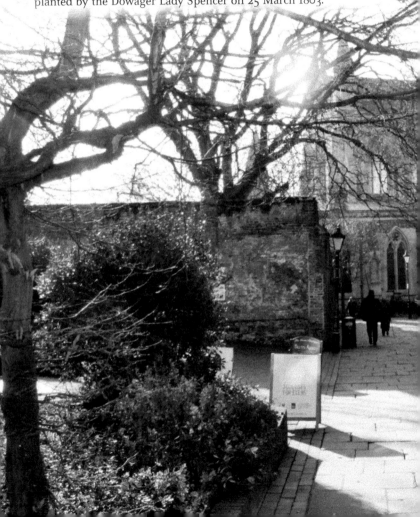

12. THE LADY CHAPEL

The Lady Chapel was, until restoration of the Abbey, separated from the rest of the church and used as a school. A nineteenth-century visitor commented: 'the arches have been walled up, and a passage made for the use of the town, between the east end and the Chapel ... it has been much neglected, and appropriated as a school-room, and the original pavement covered with a wooden floor.' He continued: 'No sepulchral memorials can consequently be seen; but it is believed that many of the nobility and gentry who fell at the two sanguinary battles of St Albans repose beneath.'

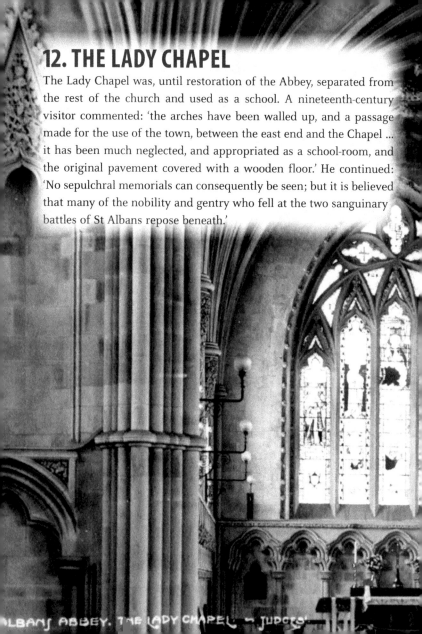

LBANS ABBEY. THE LADY CHAPEL ~ JUDGES

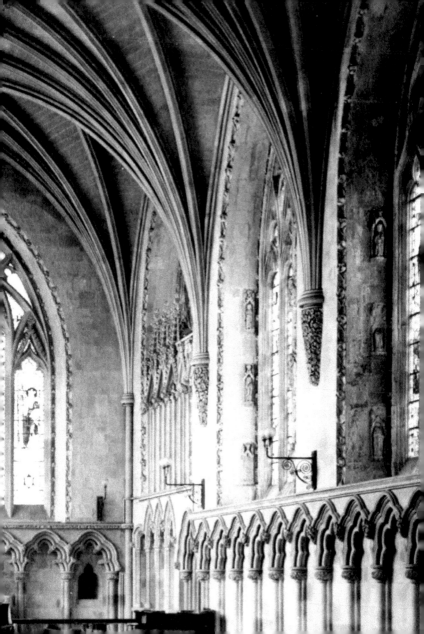

13. ABBEY NAVE

The photograph dates from the period of restoration in the 1880s. Services were conducted in the nave during this period. A contemporary report of the extensive renovation work observes that 'in excavating the floor of the nave two mutilated stone coffins were found, around 3 feet from the surface, and fragments of tiles are discovered occasionally with other interesting *debris.*'

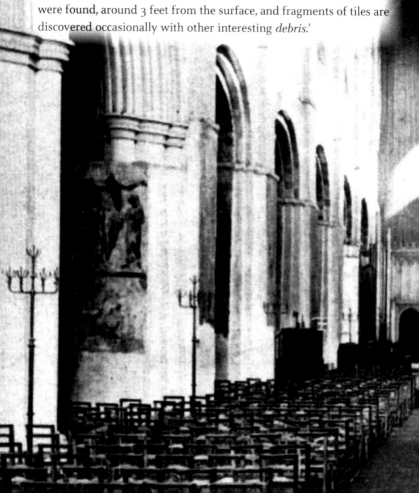

14. ST ALBANS ABBEY II

The Abbey originated on this site because during the reign of the Roman Emperor Diocletian, Albanus, a Roman official, protected a Christian preacher and was ultimately executed on 20 June AD 293. His body was buried where subsequently 'a small church' was erected. In AD 792 Offa, King of the Mercians, to expiate his sins, was told to 'erect a fair monastery to the memory of the blessed Alban, in the place where he suffered martyrdom'. Offa commenced a search for the forgotten remains of Albanus and 'assisted by clergy and people ... and [a] light from heaven ... the ground was opened and the body of St Alban discovered...' Offa used much Roman material from Verulamium to build the Abbey. Over the centuries the Abbey deteriorated badly, and under local resident Lord Grimthorpe of Batchwood Hall, the restoration was undertaken in the 1880s. The photograph shows rubble waiting to be removed in 1885.

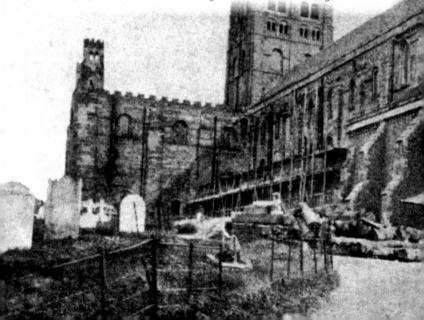

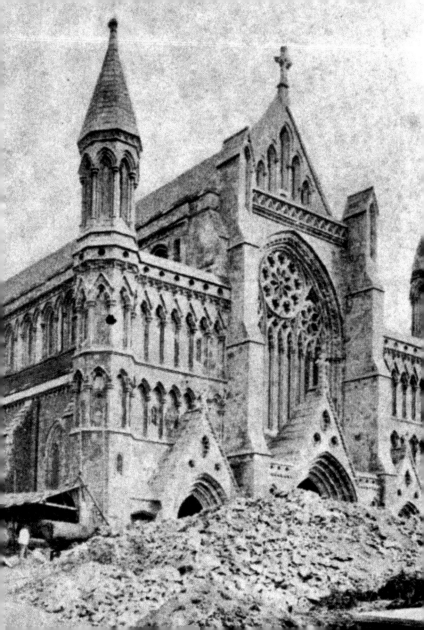

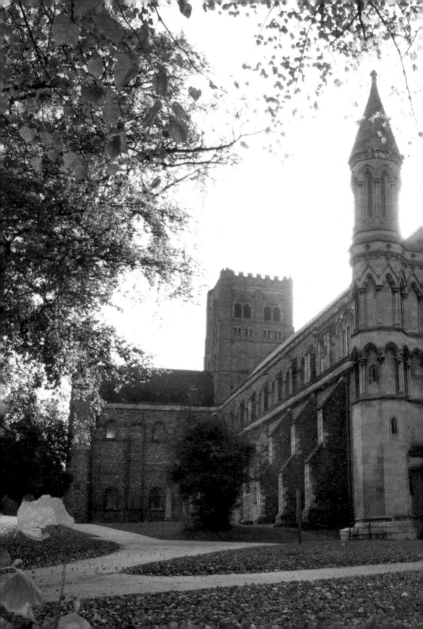

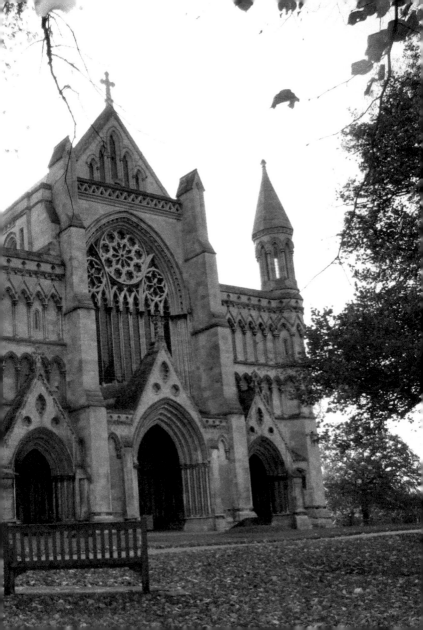

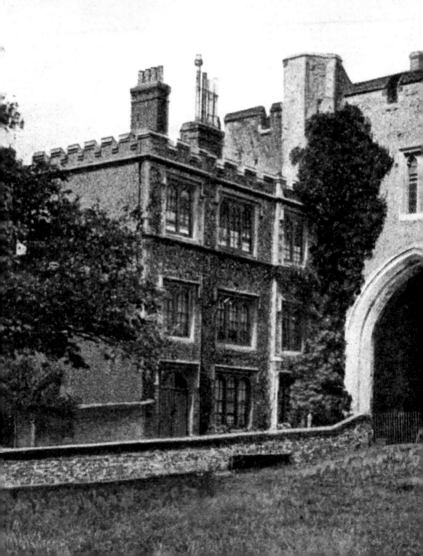

Old Gateway, St. Albans.

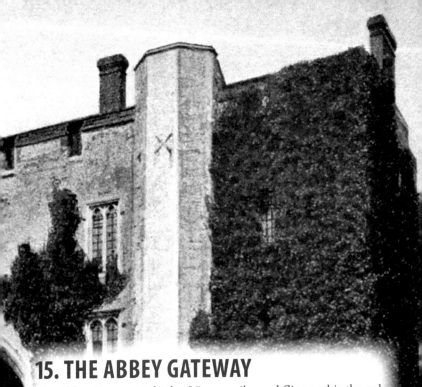

15. THE ABBEY GATEWAY

The Abbey Gateway is built of Roman tiles and flint, and is the only remaining part of the monastery, to which it was the gateway. It was built around 1360, while Thomas de la Mare was Abbot. It was besieged in 1381 during the Peasants' Revolt, one of the leaders of which, the radical priest John Ball, came from St Albans. The Abbot John of Whethamstede (d. 20 January 1465), from a window of the Gateway, observed and recorded the vicious fighting during the First Battle of St Albans which was taking place a few hundred metres away around the Clock Tower and Market Place. It also housed the third printing press in England, from 1479. The building was used as a prison between 1553 and 1869. Since 1871 it has been part of St Albans School. The postcard dates from *c*. 1905.

16. WAXHOUSE GATE II

The old photograph dates from *c.* 1880. Of the Waxhouse Gate itself, part of the base of the walls remains, but the arch which now represents it is a plain round-headed, eighteenth-century opening.

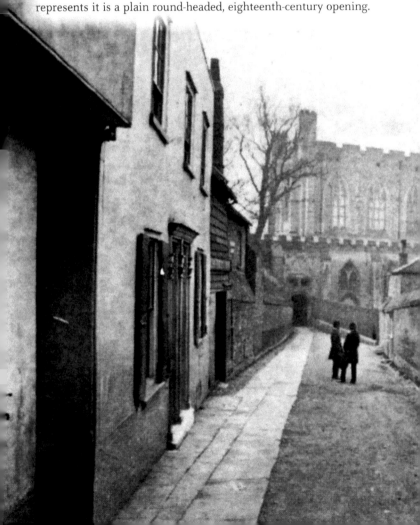

17. THE PEMBERTON ALMSHOUSES

The *Victoria County History of 1908* says of the Almshouses: 'Opposite [St Peter's Church] are the Pemberton Almshouses, built of red brick, of a single storey, with square-headed mullioned windows of two lights, and six plain round-headed doorways. They are set back a little from the road, with a garden in front bounded by a low red-brick wall, and entered through a tall central gateway, over which is an inscription, dated 1627, recording their foundation by Roger Pemberton, who is buried close by in St Peter's Church. Tradition says that the iron spike over the gateway represents the shaft of an arrow, and that the founder once shot a widow by accident, and built the almshouses for an atonement. There seems, however, to be no foundation for this story.'

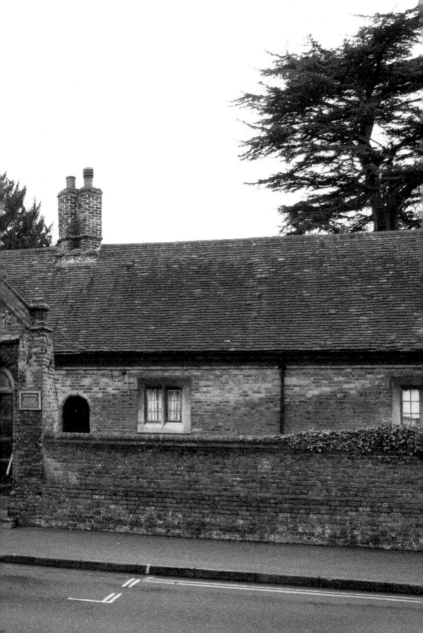

18. CHURCHYARD AND ENTWISTLE BRASS

The northern end of St Peter's churchyard is the likely burial place of many of the fallen. An early source states, 'This Church and Churchyard was stuffed full with the bodies of such as were slain in the two battles, fought here at St Albans.' Inset, the brass of Sir Bertine Entwistle killed by a severe sword wound to the shoulder in the first battle and buried under the floor of St Peter's. The brass was damaged by builders in 1797. The remaining lower half is in the British Museum. (Courtesy Tom Entwistle)

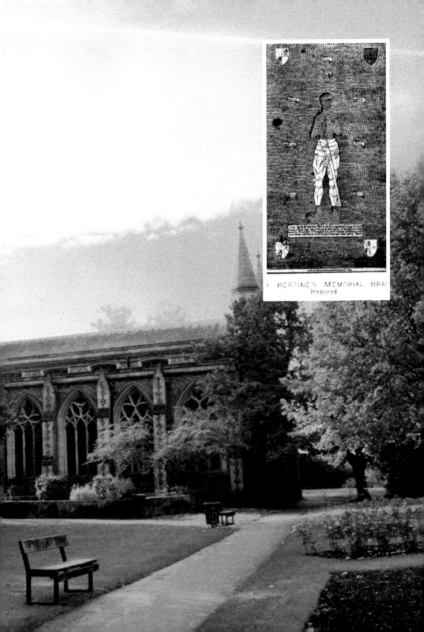

SIR BERTINE'S MEMORIAL BRASS
Restored

19. ST PETER'S CHURCH

This photograph of St Peter's church was taken before Lord Grimthorpe's restoration work of 1894–95. According to Matthew Paris, a thirteenth-century abbot, Ulsinus founded St Peter's in 948. In 1799 the tower had become so dangerous that it was taken down to the level of the crossing arches and finally in 1801 the belfry floor fell in. The new tower, which was erected in brick, was essentially as is seen today in size and shape. In 1893, Lord Grimthorpe's restoration left an essentially Victorian church with some traces of earlier centuries.

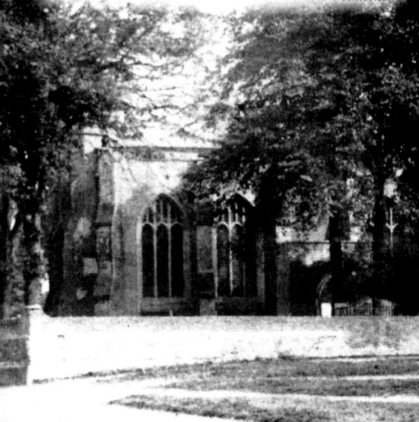

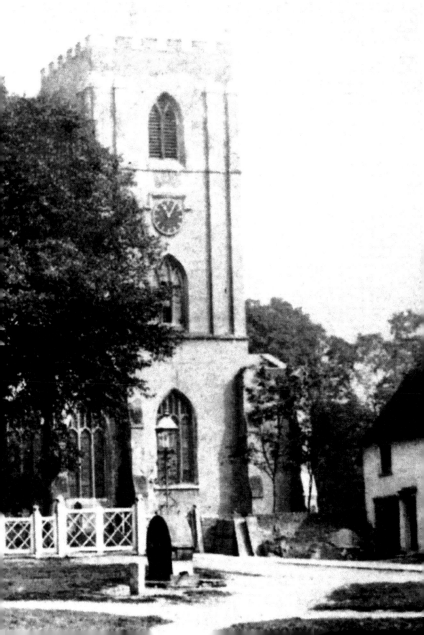

20. ST PETER'S STREET

The postcard dates from *c.* 1905 and looks from south to north with St Peter's church at the far end. St Peter's Street was in 1245 described as the magnovico or 'great street'.

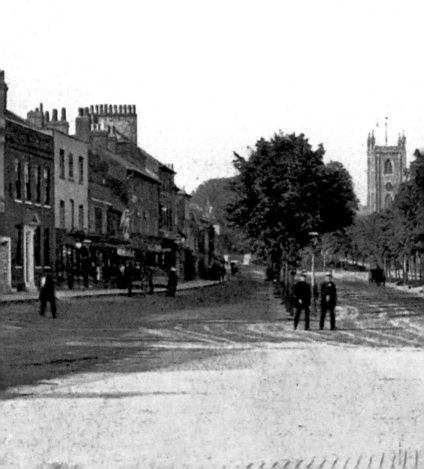

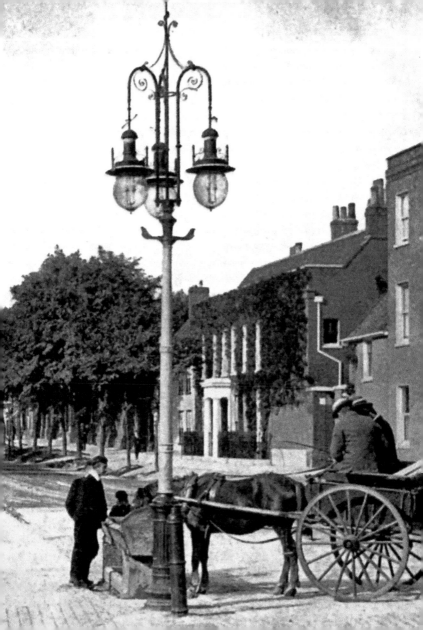

21. FIRST BATTLE OF ST ALBANS

Henry VI raised the Royal Standard, a declaration of war, in the vicinity of what is now the Boots store in St Peter's Street. It was here that he was injured in the neck by an arrow. Four of the King's bodyguard were killed and the Royal Standard was abandoned. It was in Sopwell Lane that the Earl of Salisbury attacked the defences held by Lord Clifford's men.

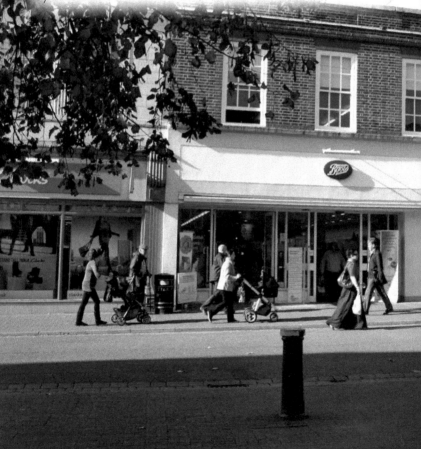

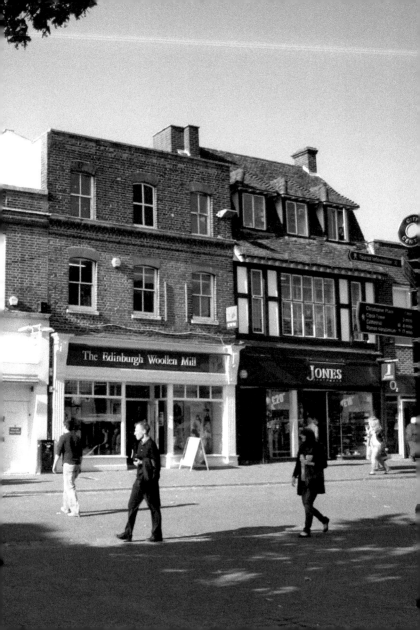

22. THE DEATH OF THE DUKE OF SOMERSET

The photograph of Connells opposite the Skipton (inset) is where the Duke of Somerset was killed. A contemporary source describes his demise: 'York's men at once began to fight Somerset and his men, who were within the house and defended themselves valiantly. In the end, after the doors were broken down, Somerset saw he had no option but to come out with his men, as a result of which they were all surrounded by the Duke of York's men. After some were stricken down and the Duke of Somerset had killed four men by his own hand, so it is said, he was felled to the ground with an axe, and at once wounded in so many places that he died.' In the background to the right is the site of the old Moot Hall. The main photograph depicts the River Ver. St Michaels was the scene in the Second Battle of St Albans where at dawn on 17 February 1461 the Queen's army attacked the Yorkists already occupying the town. They crossed the River Ver, in the vicinity of St Michael's church, advanced up Fishpool Street, Romeland Hill and George Street until they reached the Market Place. They were fired on by Yorkist archers from the windows of the surrounding buildings in the town centre. The Lancastrians were pushed back down George Street and regrouped at the River Ver ford.

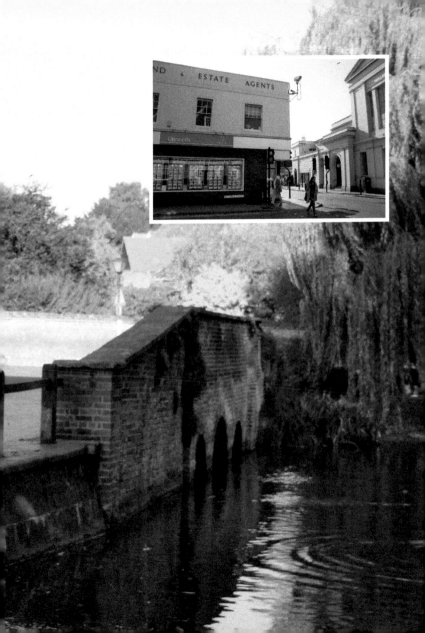

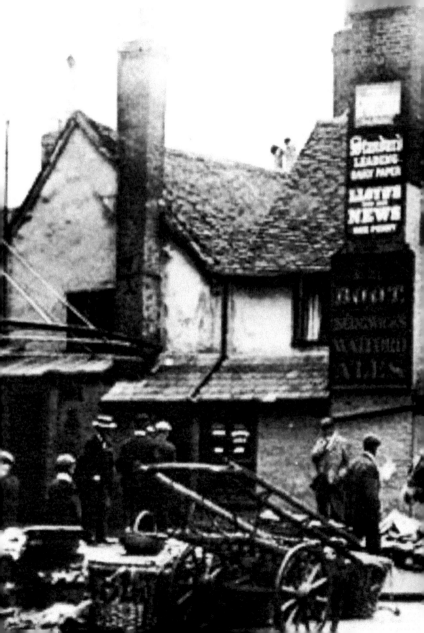

23. THE BOOT

The Boot, a public house, was originally built *c.* 1500 in the Market Place. The building was originally made up of two timber-framed buildings. Each building had two ground-floor rooms with chambers over on the first floor. The upper floors projected out on the front and north sides. It is first recorded as a licensed house in 1719. In 1756, it could provide accommodation for the billeting of four soldiers but had no stabling.

24. THE MARKET PLACE

The *Victoria County History of 1908* tells us: 'Around the Market Place, which was apparently on the same site as it was at the time of its enlargement by Abbot Walsin in the tenth century, stood the principal buildings. At the south end was the Eleanor Cross, Queen Cross, or Market Cross erected by Edward I to commemorate the resting-place of the body of Queen Eleanor on its journey from Lincolnshire to Westminster in 1290, on the site of which stands a drinking fountain erected by Mrs Worley in 1874. In the seventeenth century the cross was allowed to get out of repair, and about 1700 the last vestiges of it were carted away to make room for the Market Cross erected in 1703, an octagonal building with a roof supported upon eight columns above which was the figure of Justice, and within it was the town pump worked by a large wheel. This building was taken down in 1810, but the pump remained for a time.'

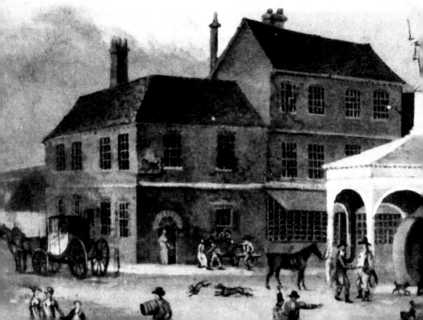

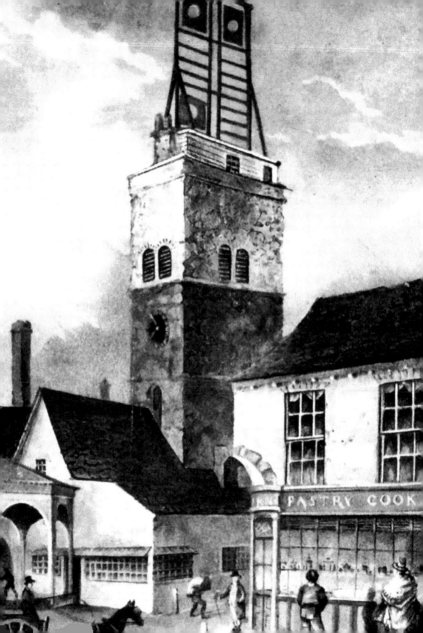

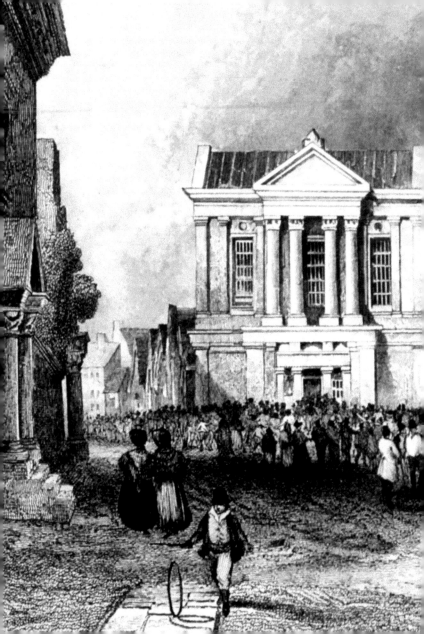

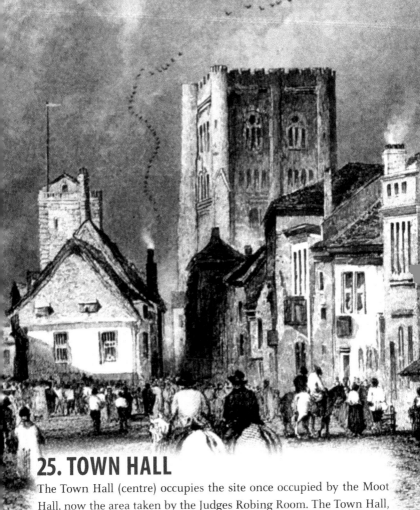

25. TOWN HALL

The Town Hall (centre) occupies the site once occupied by the Moot Hall, now the area taken by the Judges Robing Room. The Town Hall, built as a combined court house and town hall, was opened in 1831. The building to the right, still standing, is 'The Gables', built in 1637. The 1835 illustration uses artistic licence with its proportions.

26. FRENCH ROW

The buildings in French Row date from the fourteenth century. The Fleur-de-Lys inn is where the French King, John, was reputedly imprisoned in 1356 following the Battle of Poitiers, but this is unlikely. In 1420–40, Abbot Wheathampstead paid for the construction of a brewery in French Row. Excavations prior to the construction of Christopher Place behind the western side of French Row/Market Place revealed the stone footings for fourteenth/fifteenth-century timber. The photograph dates from 1890.

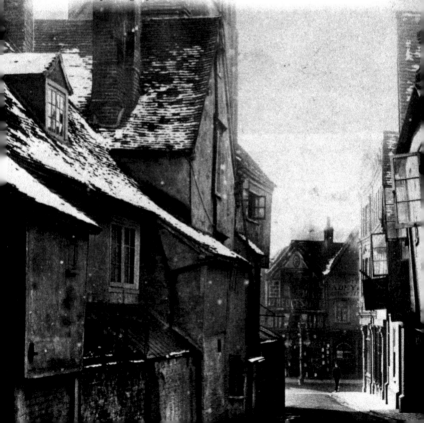

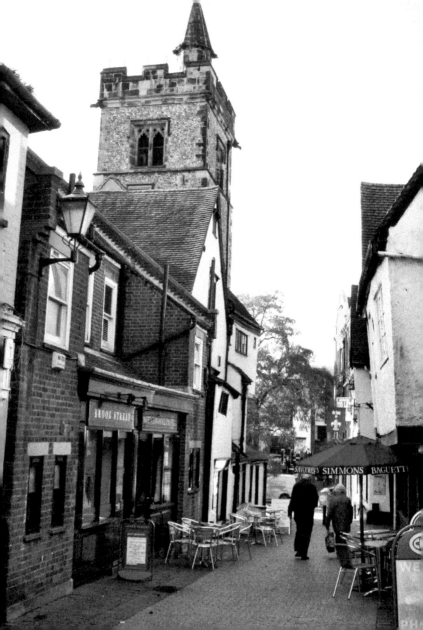

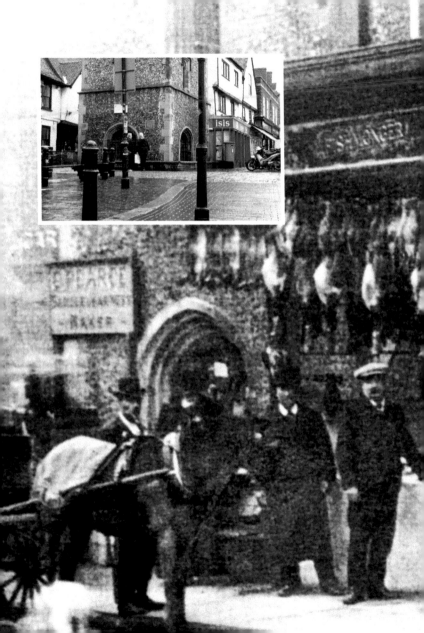

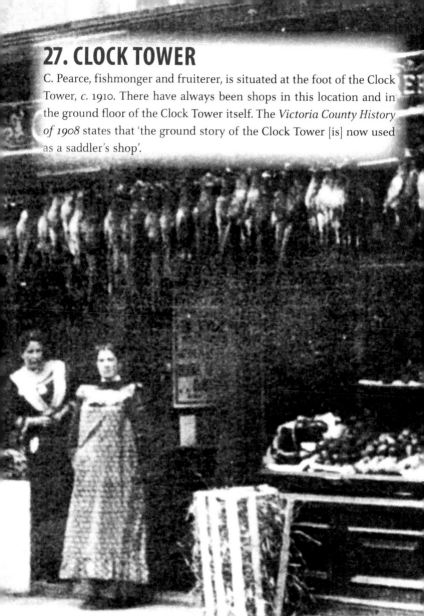

27. CLOCK TOWER

C. Pearce, fishmonger and fruiterer, is situated at the foot of the Clock Tower, *c.* 1910. There have always been shops in this location and in the ground floor of the Clock Tower itself. The *Victoria County History of 1908* states that 'the ground story of the Clock Tower [is] now used as a saddler's shop'.

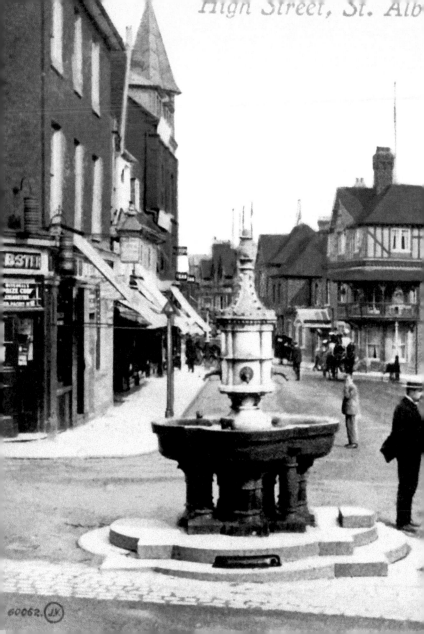

High Street, St. Alb

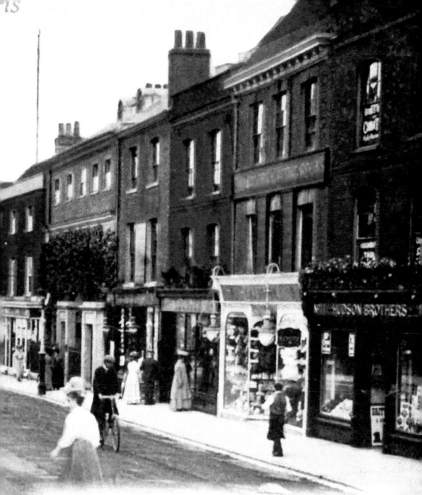

28. HIGH STREET AND FOUNTAIN

The postcard dates to 1905. In the foreground is Mrs Worley's drinking fountain. Mrs Worley was a wealthy widow who gave this drinking fountain to the town in the 1870s.

29. CORN EXCHANGE

The *Victoria County History* of 1908 tells us of the Corn Exchange, now the Reiss building: 'On the east side of the present Market Place stands, detached on all sides, the Corn Exchange, an inartistic building of white brick, which, in 1857, took the place of an ancient open market-house supported on wooden piers.' There had been complaints about this old building for at least half a century before due to its open sides which allowed the rain in, spoiling farmers' sacks of grain. The cost of the new building, £1,470, was raised by public subscription and the new building, designed by Coventry architect James Murray, was opened in September 1857 by the mayor of St Albans, John Lewis.

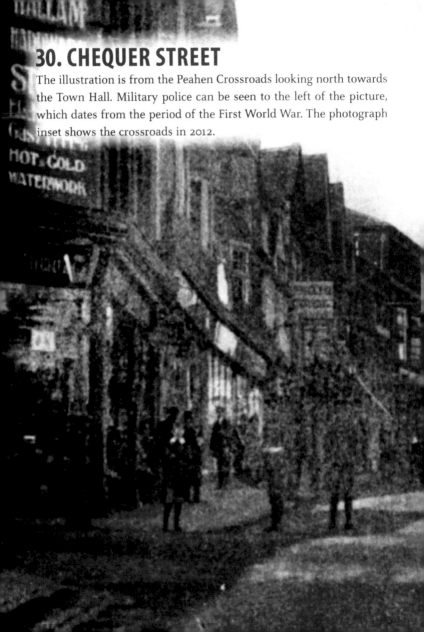

30. CHEQUER STREET

The illustration is from the Peahen Crossroads looking north towards the Town Hall. Military police can be seen to the left of the picture, which dates from the period of the First World War. The photograph inset shows the crossroads in 2012.

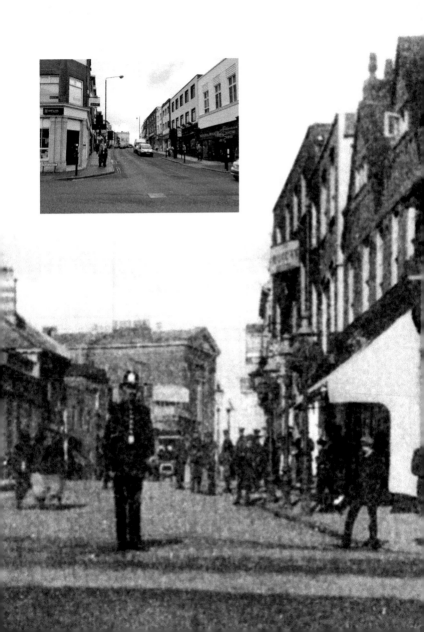

31. MICHAELMAS FAIR

'The Michaelmas Fair, St Albans, 1852,' (inset) by J. H. Buckingham 1800–81. Buckingham's rough and ready work shows the approach to St Albans up Holywell Hill, a sight which horse and driver alike must have dreaded (extra horses could be hired for the ascent). Fortunately, he never 'tidied' his scenes, and so we see the traffic as it must have been, with pedestrians, horses, cattle, carts and carriages using the road at random. The view of St Peter's Street shows a fair with stalls and booths, a Ferris wheel and a coconut shy or 'Aunt Sally'. The two- and four-legged traffic includes donkey rides and a children's toy carriage drawn by a goat. The roadway is rough and wide, with no very clear demarcation between carriageway, pavement, and fair; the same could be said on market days. (St Albans Museum)

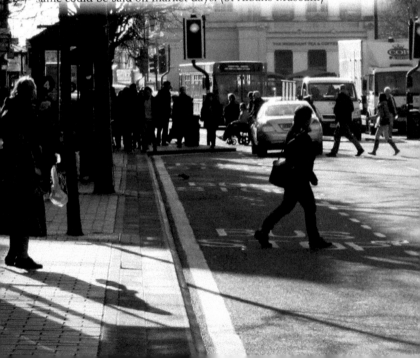

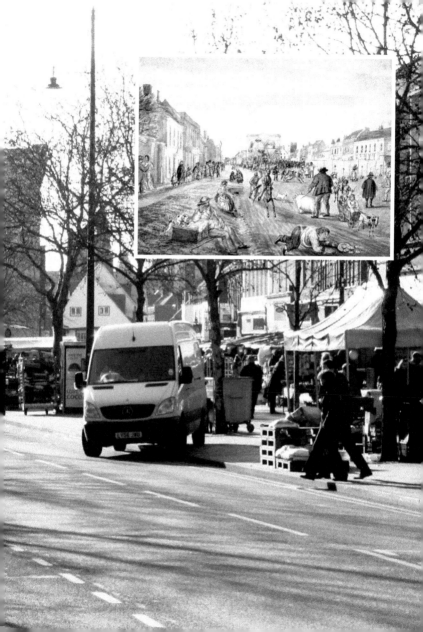

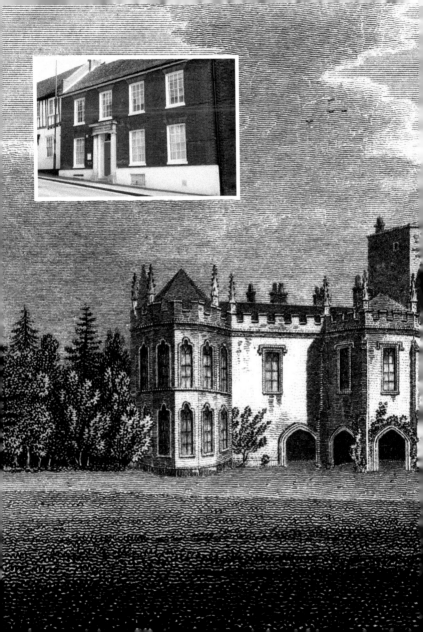

32. HOLYWELL LODGE

At No. 41 Holywell Hill on the east side of the road is Holywell Lodge. The lodge is a Grade II-listed building, with a frontage that dates to the early nineteenth century; it possibly hides a building of earlier origin. The lodge is a remaining echo of the former Holywell House which was knocked down in 1837 and stood close by.

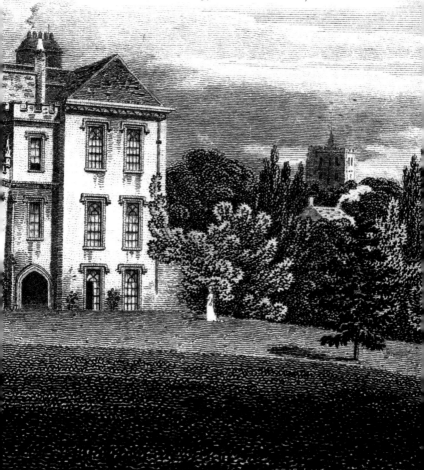

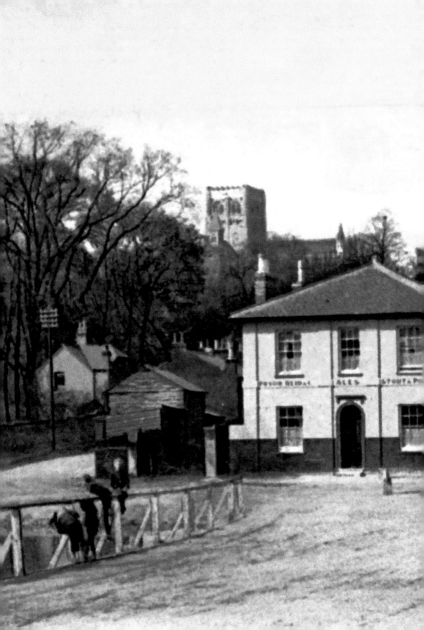

33. A VIEW LOOKING UP HOLYWELL HILL

The postcard dates from *c.* 1905 and shows the Duke of Marlborough pub. The pub dates from *c.* 1825.

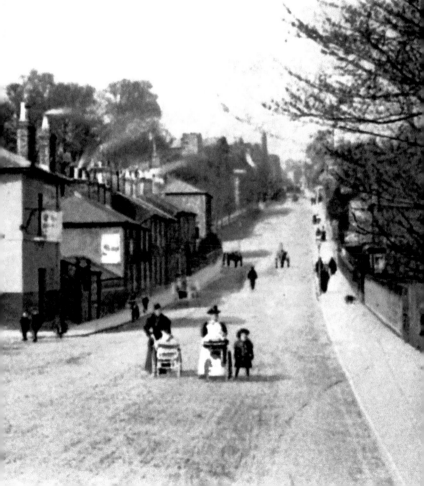

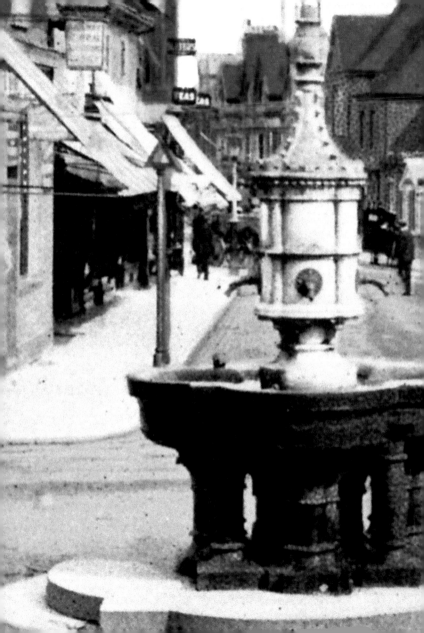

34. MRS WORLEY'S FOUNTAIN

Mrs Worley's fountain is situated behind the old prison (now the registry office) on Grimston Road, St Albans. This fountain was designed by the architect George Gilbert Scott. Mrs Worley was a wealthy widow who gave this drinking fountain to the town in the 1870s. Originally, it was situated in front of St Albans Clock Tower on High Street. However, as traffic increased it became too obstructive and was moved in the 1920s. It was found on a council tip and was relocated here.

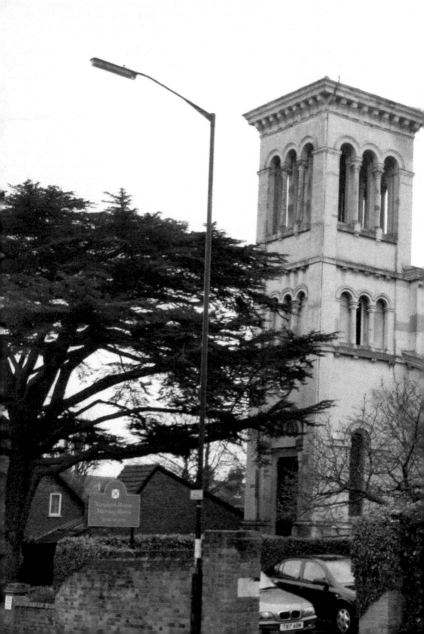

35. CHRIST CHURCH

Christ Church was begun as a Catholic church by the MP Raphael before his sudden death in 1848. It remained unfinished until Mrs Worley completed it as a private chapel. It is now converted into offices.

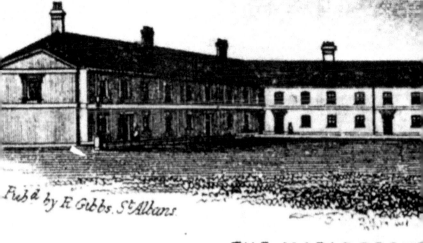

Pub'd by R. Gibbs, St Albans.

THE MARLBOROU

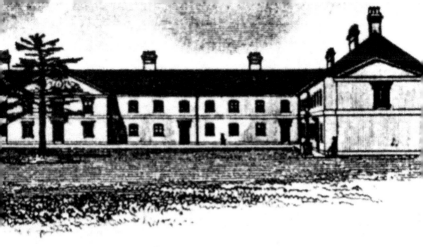

BUILDINGS, St ALBANS.

36. MARLBOROUGH BUILDINGS ALMSHOUSES

The Marlborough Buildings almshouses were founded and endowed by Sarah, Duchess of Marlborough, a sometime resident of Holywell Hill, in 1736. They were intended to provide accommodation for '36 decayed men and women'. They stand opposite the St Albans Museum in Hatfield Road.

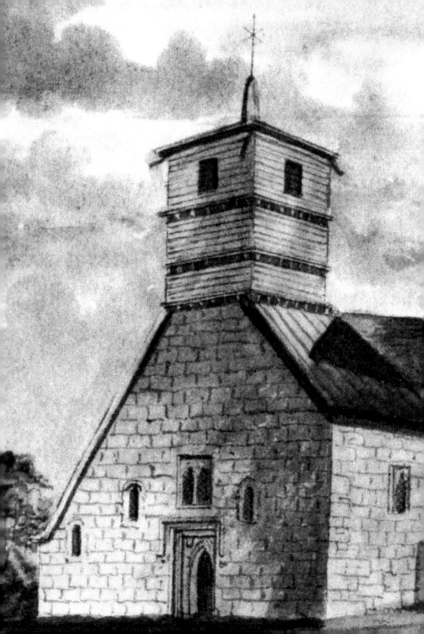

37. ST STEPHEN'S CHURCH

St Stephen's church in 1824. One of the three built by Abbot Ulsinus, it is situated to the south of St Albans on Watling Street. The original late Saxon building consisted of a nave and chancel, to which aisles were added. The church was consecrated between 1101–1118 and probably dates from the tenth century.

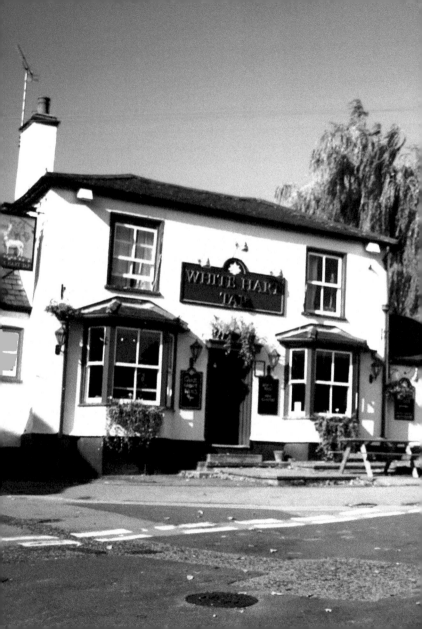

38. KEYFIELD AND WHITE HART TAP

The opening conflict of the Wars of the Roses happened in St Albans on 22 May 1455. The first battle of St Albans resulted in a Lancastrian defeat after King Henry VI occupied the town, but was ousted by Yorkist forces led by the Earl of Warwick after a skirmish in the town centre. By 7.00 a.m. the Duke of York, Salisbury and Warwick, 'with divers knights and squires', arrived at Key Field, now the site of a car park best seen from the outdoor terrace of the White Hart. A couple of hours later the royal party marched into St Peter's Street.

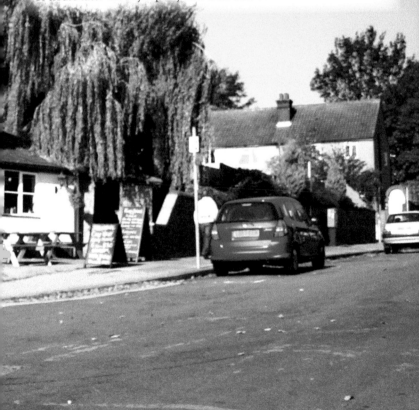

39. BERNARDS HEATH

The fighting on Bernards Heath became a grim slugging match, with both sides anxiously waiting for reinforcements. It was here that the Yorkist forces broke and fled. The site of the gallows and old burial ground are immediately to the left under what is now a block of flats. Below, Nomansland Common where the Yorkists rallied for a last stand and the exhausted Lancastrians withdrew to St Albans. Warwick probably retreated down Ferrers Road, to the right of the car park.

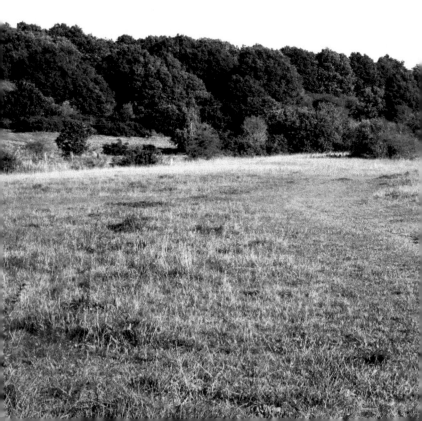

40. BEECH BOTTOM DYKE

The hauntingly quiet and atmospheric earthwork is now a scheduled monument. It was probably constructed between AD 5 and 40 by the Catuvellauni to demarcate their land. It is still clearly defined with a depth of up to 10 metres and a width of 30 metres.

BEECH BO

THE MASSIVE D
THIS POINT FO
PRE-ROMAN EA
RUNS FROM TH
VERULAMIUM TO
IT DATES BETWE

TTOM DYKE

CH AND BANK AT
MS PART OF THE
THWORK WHICH
BELGIC CITY OF
WHEATHAMPSTEAD.
N 50 B.C. & 50 A.D.

41. BEECH BOTTOM DYKE II

The stretch in the photographs runs for half a mile between the 'Ancient Briton' crossroads just north of Beech Road to where it is crossed by the railway at Sandridge. A footpath runs for the full half-mile length of this stretch of dyke. In 1461 it was used as a defence by the Earl of Warwick (Warwick the Kingmaker) at the second battle of St Albans. As you walk along the dyke, and reach the railway embankment, it is possible that here were buried a number of victims of the battle. There are unproven accounts of human remains and battle debris being unearthed in the 1860s.

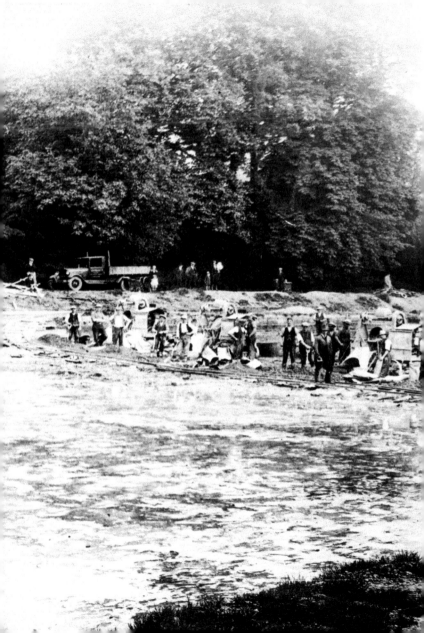

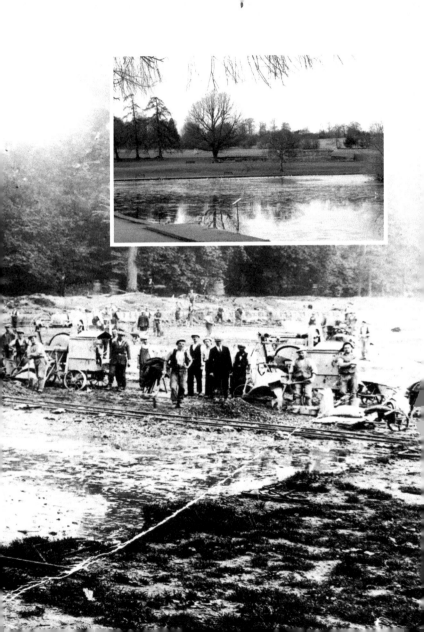

Also Available from Amberley Publishing

ROBERT BARD

ST ALBANS

THROUGH TIME

This fascinating selection of photographs traces some of the many ways in which St Albans has changed and developed over the last century.

Paperback
180 illustrations
96 pages
978-1-4456-0726-9

Available from all good bookshops or to order direct
please call **01453-847-800**
www.amberley-books.com